584.64		3074
WEXL	Wexler, J.	
AUTHOR		
	Jack-in-the-pulpit	
TITLE		
(X.)		('94)

DATE DUE	BORROWER'S NAME	ROOM NUMBER
out 3/22	k ⬠ t'l ⊙W kdg.	
5-10	robert	
2.7	Sam	2

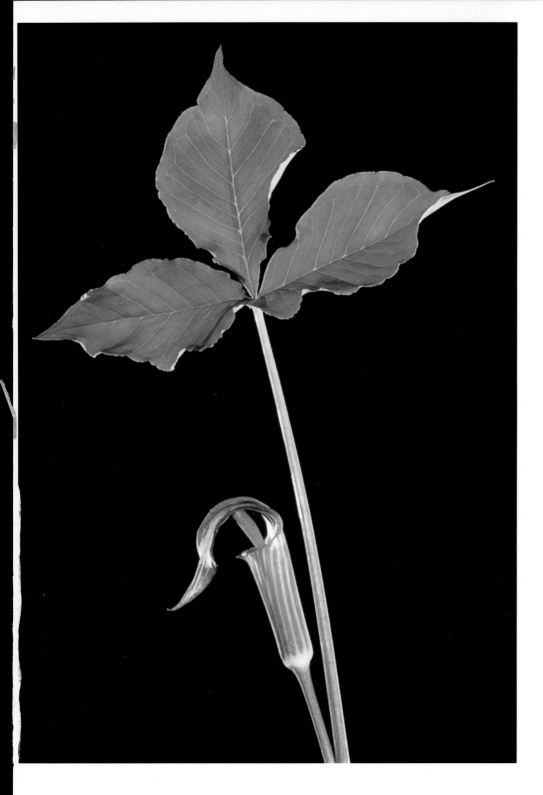

JACK-IN-THE-PULPIT

Jerome Wexler

Dutton Children's Books New York

All of the jack-in-the-pulpit flowers shown in
this book are from cultivated plants that were raised
from seed in a plant nursery.

Library of Congress Cataloging-in-Publication Data
Wexler, Jerome.
Jack-in-the-pulpit / Jerome Wexler.—1st ed.
p. cm.
Summary: Describes the structure and life cycle of the wildflower
known as the jack-in-the-pulpit.
ISBN 0-525-45073-4
1. Jack-in-the-pulpit—Juvenile literature. [1. Jack-in-the-pulpit.
2. Flowers.] I. Title.
QK495.A685W48 1993
584′.64—dc20 92-44375 CIP AC

Published in the United States 1993 by Dutton Children's Books,
a division of Penguin Books USA Inc.
375 Hudson Street, New York, New York 10014
Designed by Riki Levinson
Printed in Hong Kong First Edition
10 9 8 7 6 5 4 3 2 1

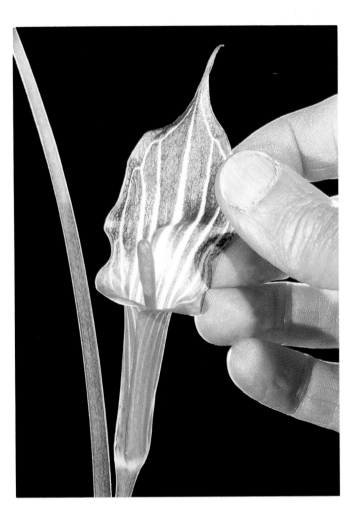

Jack-in-the-pulpit. What a strange name for a wildflower! Perhaps a more dignified name might be preacher-in-the-pulpit.

A pulpit is a small, enclosed platform where a preacher can stand to give a sermon. The walls around the pulpit help bounce the sound of the preacher's voice out to the whole congregation.

The plant is called jack-in-the-pulpit because of the shape of its flower structure, which you see here. To some people, it looks like a preacher surrounded by the curved walls of an old-fashioned church pulpit.

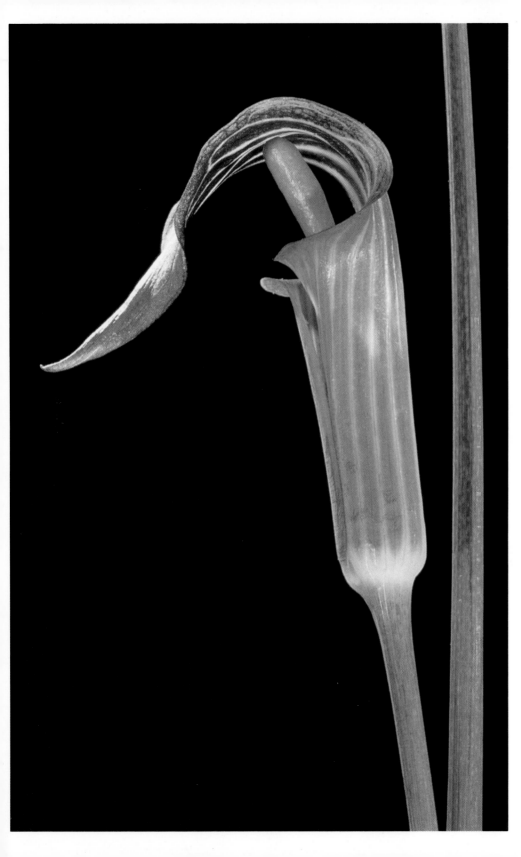

What does it look like to you?

A jack-in-the-pulpit appears to be a simple plant. It has only
one or two compound leaves plus a flower structure in the center.
Although the flower structure is not a conventional flower with
petals, it serves an important purpose, as you will see.

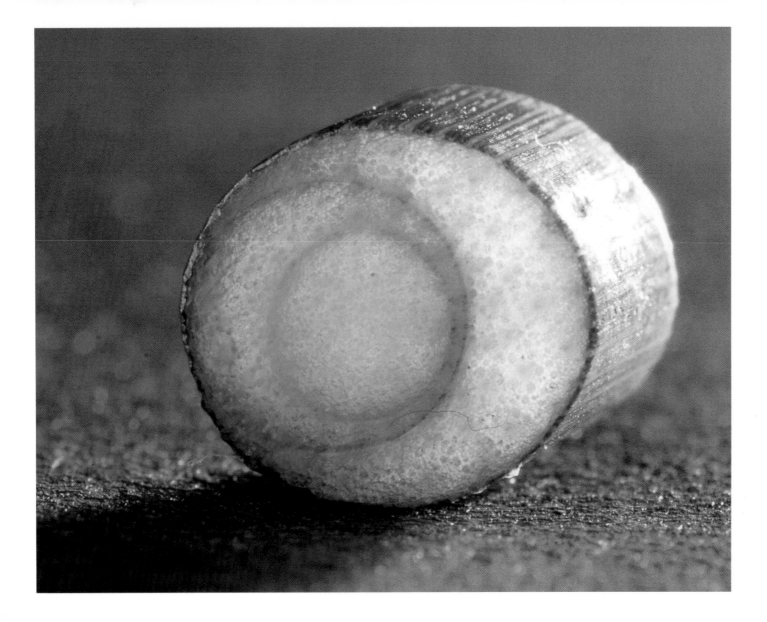

Here is a cross section of a jack-in-the-pulpit stem, cut just a few inches above the soil. It shows how the leaves and flower structure grow as one. The circle in the center is the stem of the flower structure. Wrapped around it are the stems, or petioles, of the plant's two leaves. They all form a tidy unit.

A jack-in-the-pulpit leaf is called a compound leaf because three small leaflets combine to make one big leaf with a single petiole.

But look twice before touching!

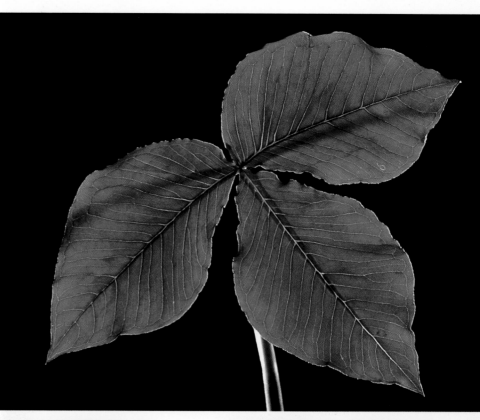

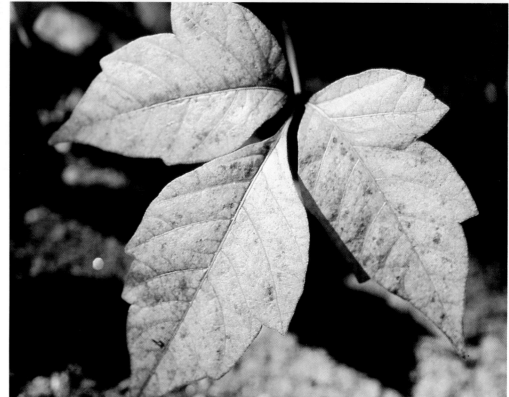

Under certain conditions, the three notched leaves of poison ivy can look very much like the three leaflets of a jack-in-the-pulpit. So be careful!

Jack-in-the-pulpits can be found in the eastern United States and Canada. They grow best in moist, shady areas where sunlight is filtered by foliage. Occasionally, however, jack-in-the-pulpits grow well in rather dry, grassy areas that receive full sunlight.

The plants vary in size, depending on their age and location. Some are only eight to ten inches high, while others grow to be over three feet tall with a leaf span of two feet or more.

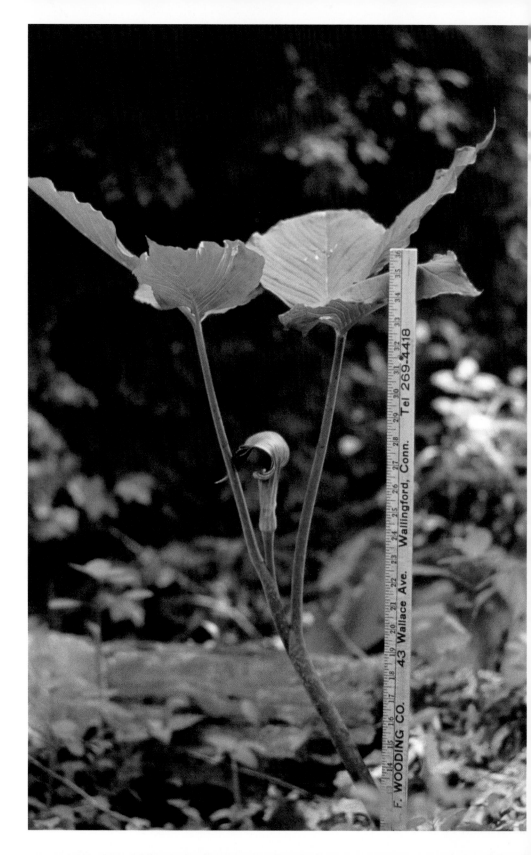

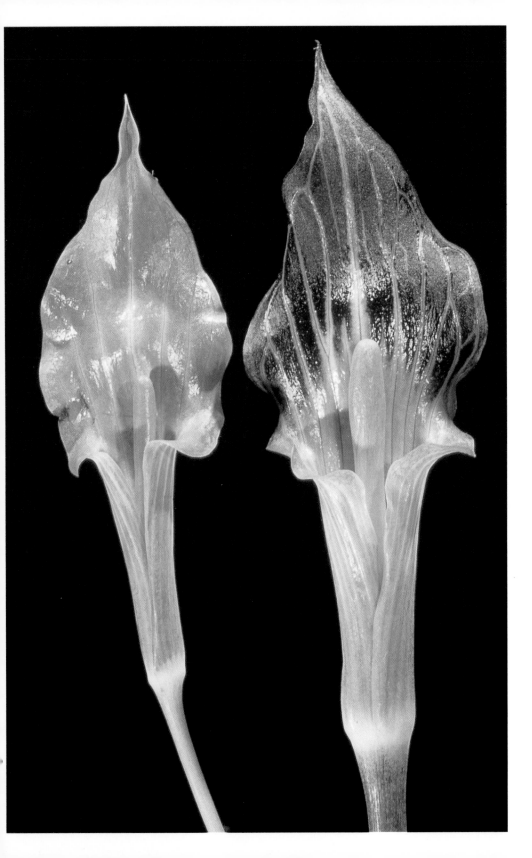

If you are hiking and come across a group of jack-in-the-pulpits, you may want to examine their flower structures. (But don't pick any.) One of the first things you will notice is that the pulpit and its hood seem to come in two colors—green and purple.

Here, part of the pulpit has been cut away.

In the center is a long, clublike structure. This is the "jack" of "jack-in-the-pulpit." The words *jack* and *pulpit* are just nicknames. Botanists—people who study plants—call the jack a spadix. They call the pulpit a spathe.

Spadix-in-the-spathe? Too much of a tongue twister! So let's continue to call the plant a jack-in-the-pulpit.

Although the spathe and spadix may look like one large flower, together they form a structure, called an inflorescence, that holds many tiny flowers. These tiny flowers help make seeds. They grow inside the spathe, near the base of the spadix. Can you see them? They have no petals, and they are very, very small.

Usually the flowers at the base of the spadix are either all male or all female. Male flowers produce pollen, which contains male reproductive cells.

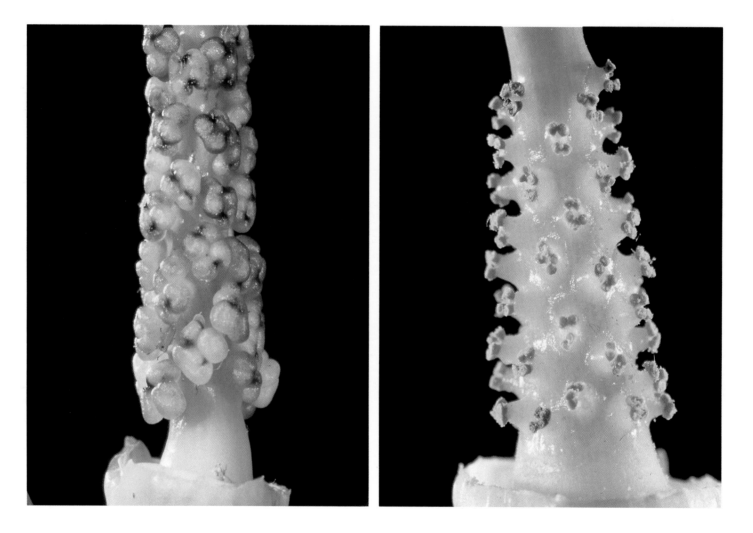

Here are male flowers just beginning to develop near the base of the spadix.

Here they are in their pollen-bearing stage.

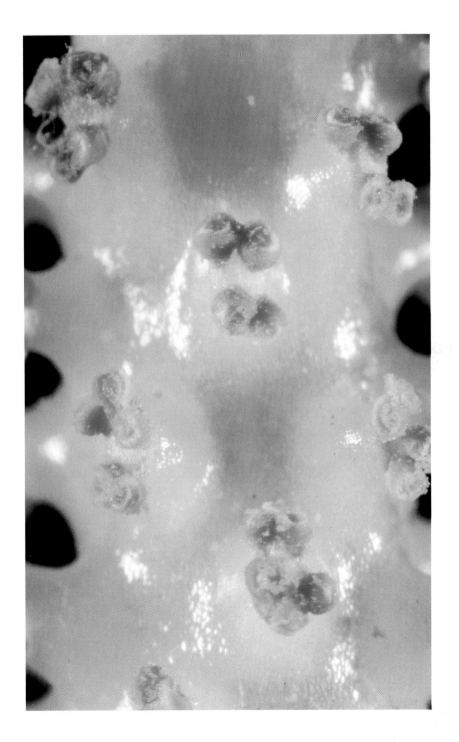

And here they are again, magnified further. Because stamens are the parts of male flowers that produce reproductive cells, male flowers are also called staminate flowers. The tiny stamens are difficult to see, but you can just make out the grains of pollen on them. They look like pinkish yellow grains of sugar. Each grain contains two male reproductive cells. When pollen grains are mature, they fall off the stamens and collect at the base of the spathe.

Here are female jack-in-the-pulpit flowers growing near the base of the spadix.

Each one looks like a little green ball topped by a white pom-pom. This ball-and-pom-pom structure is called a pistil, so female flowers are also called pistillate flowers.

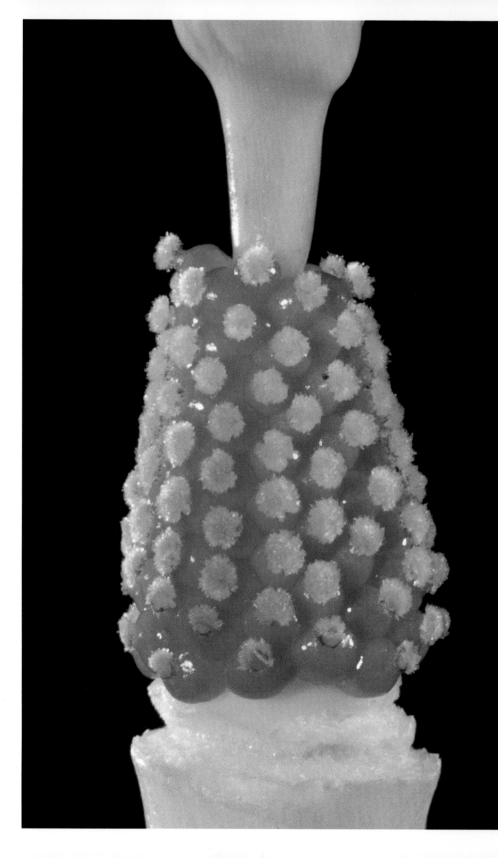

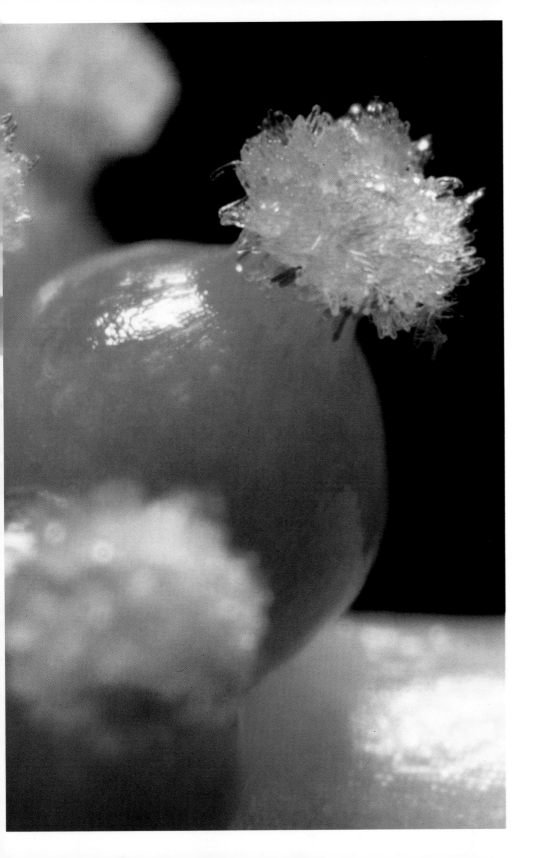

Each green ball is actually a female flower's ovary. Inside it are the female reproductive cells, called ovules. The pom-pom is a sticky structure known as the stigma. It catches and holds on to any pollen that comes its way.

Occasionally, a jack-in-the-pulpit is found with both male and female flowers growing on its spadix, like the one shown here. And sometimes a jack-in-the-pulpit that has been producing only one kind of flower will switch after several seasons and produce the other. This has to do with environmental conditions. Female flowers need plenty of nourishment for the extra energy it takes to make seeds.

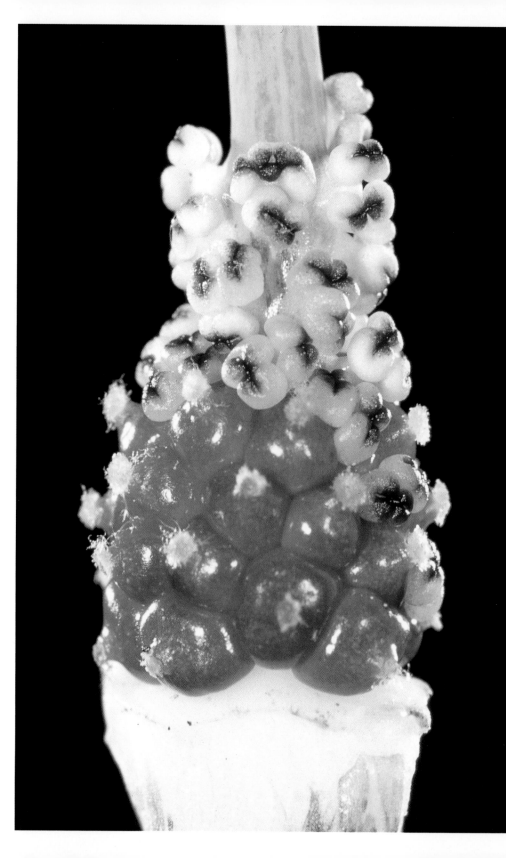

Unless pollen from a male jack-in-the-pulpit flower reaches the stigma of a female jack-in-the-pulpit flower, seeds will not form. And seeds are the way in which a plant arrives at new territory and starts life again. So the movement of pollen from male to female flower is very important. Different plants use different means to do this: wind, insects, birds, other small animals, or even water.

Jack-in-the-pulpits rely on insects for pollination. The insects are so tiny that if you sat watching for hours, chances are you would probably not notice them entering or leaving the spathe. Sometimes they die there, however, and you find their remains clinging to a flower.

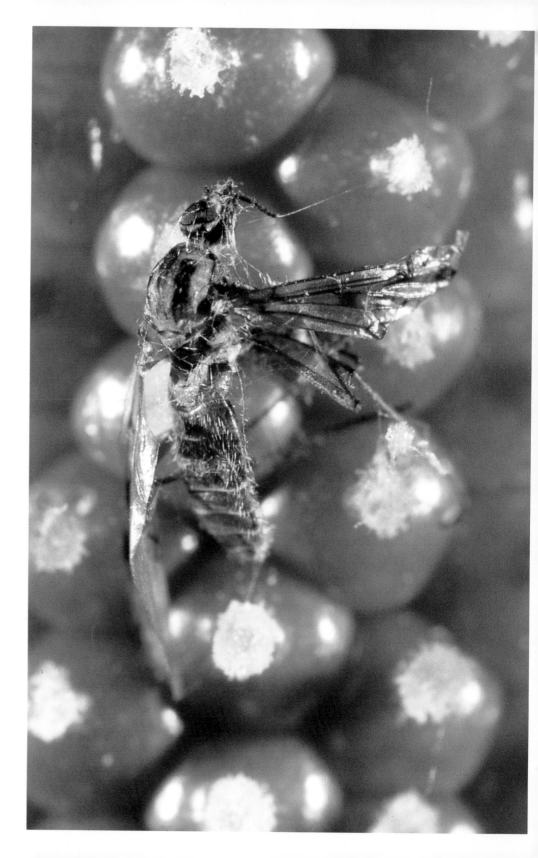

Thrips and gnats are the insects that commonly pollinate jack-in-the-pulpits. And they are *very* tiny! A thrips is less than half the size of this gnat, which is only about a quarter of an inch long.

Jack-in-the-pulpit pollen is their food.

How do the insects know there is pollen down in the spathe? It is thought that jack-in-the-pulpits give off some sort of chemical cues, or odors, which attract the insects. Up close, the spadix itself, as well as the purple color on the spathe hood, may visually signal the opening.

Plants with male flowers and those with female flowers both send out these chemical cues. When a thrips or a gnat moves around in the spathe of a male plant, eating the pollen, fine hairs on its body become dusted with pollen grains. If the insect then follows cues down into the spathe of a female flower, it won't find the pollen it is looking for, but something else will happen. Some of the pollen on its hairs will accidentally brush off onto the sticky stigmas of the female flowers.

Each grain of jack-in-the-pulpit pollen is like a package of information. When it lands on the stigma of a female flower, it goes into action. It germinates and sends a little tunnel, called a pollen tube, down into the ovary of the female flower. Then two male reproductive cells (called gametes or sperm) travel down the tube.

In the ovary, one of the gametes unites with, or fertilizes, an ovule. From the fertilized ovule, a jack-in-the-pulpit seed begins to form. At first the seed is microscopic; nevertheless, it contains all the information necessary for the start of a tiny new embryo plant.

The other gamete causes the growth of a food supply for the tiny embryo plant that will develop within each seed.

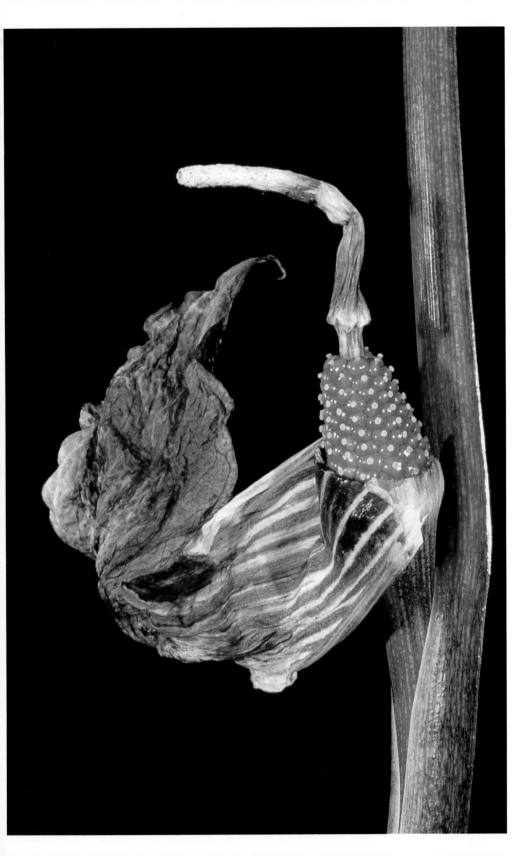

After fertilization, the spathe and part of the spadix wither. But the ovaries swell as the seeds within them begin to develop.

Botanists call an ovary that contains developing seeds a fruit. They call a jack-in-the-pulpit fruit a berry. A tomato is also called a berry. But a strawberry is not! A strawberry is not a true berry, in part because its seeds are on the outside, not the inside, of the fruit.

Throughout the summer, the jack-in-the-pulpit fruit remains green. Each berry slowly increases in size to accommodate the seeds growing within. When the seeds are mature, or ready to leave the berries for life on their own, an important change takes place.

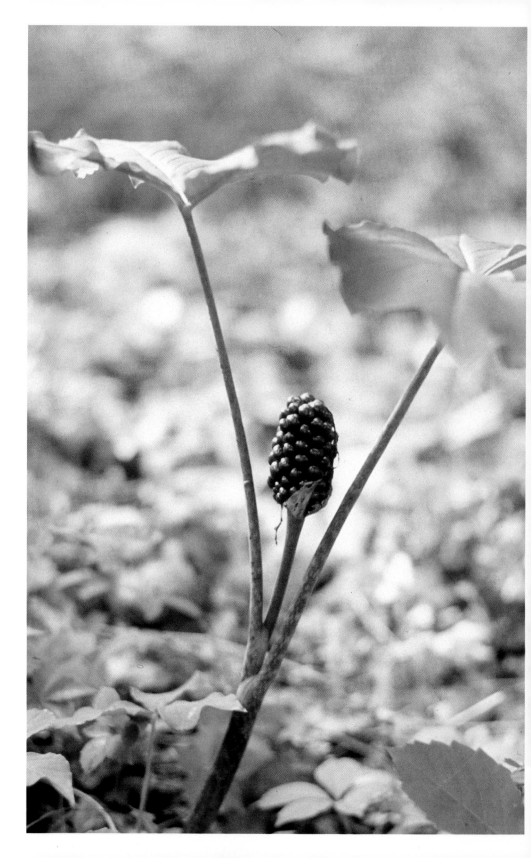

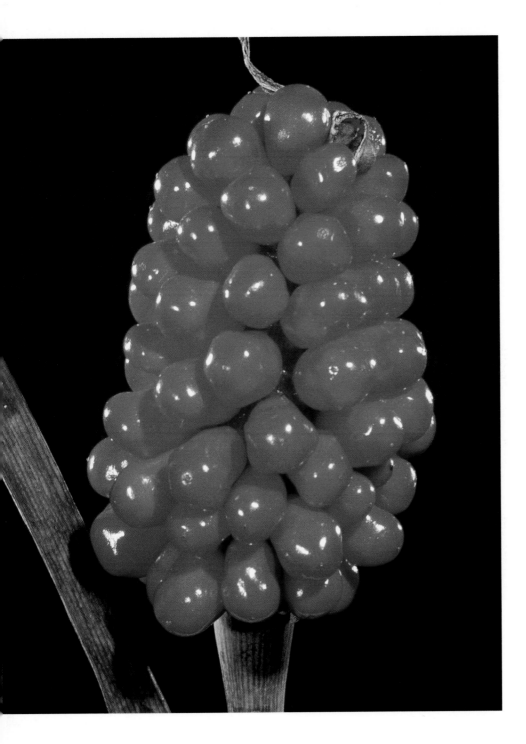

The berries turn a brilliant red.

In a woods or a field, the ripe, red berries are easy to spot. They attract birds, box turtles, deer mice, squirrels, and other animals that like to eat them.

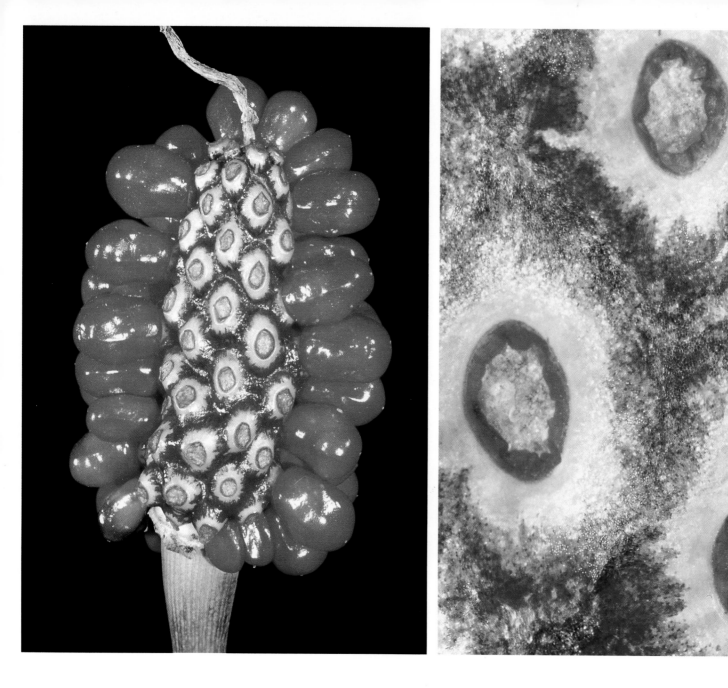

As the berries get eaten, the beautiful growing pattern at the base of the spadix is left behind.

Something else is left behind, too. Tiny seeds!

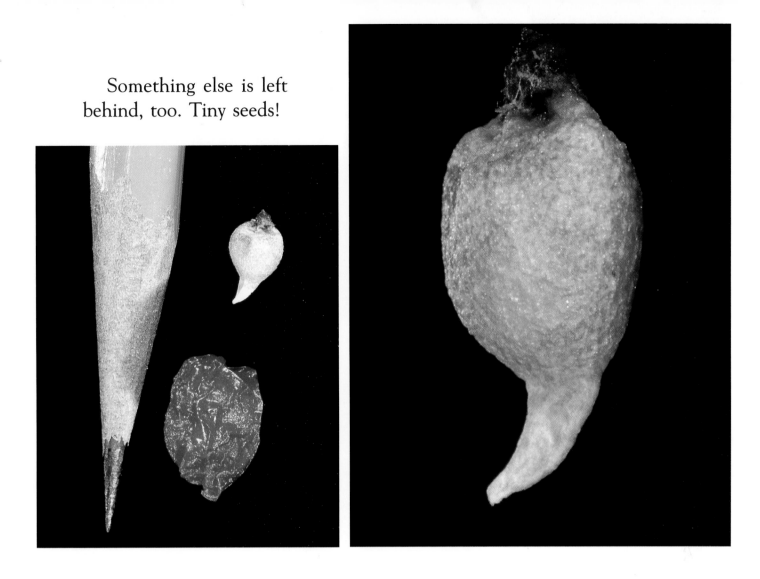

When animals eat the berries, some seeds get chewed up—but not all. The undigested seeds eventually pass out of the animals as they travel through the woods far from the mother plant. In this way, jack-in-the-pulpit seeds arrive in new areas every fall.

The seeds wait out the winter wherever they happen to land. Come spring, a seed in a good place—a moist, shady spot—may start to sprout. The embryo within, supported by its food supply, will send down roots and send up a first leaf.

This seed, which has been removed from the ground so you can see its new roots and leaf, has started to sprout.

What happens if an animal eats jack-in-the-pulpit berries while they are still green, before the seeds are ripe? The seeds would pass through the animal, but they would not sprout. Seeds of unripe fruit are not viable. In terms of helping to create new jack-in-the-pulpit plants, they would be wasted.

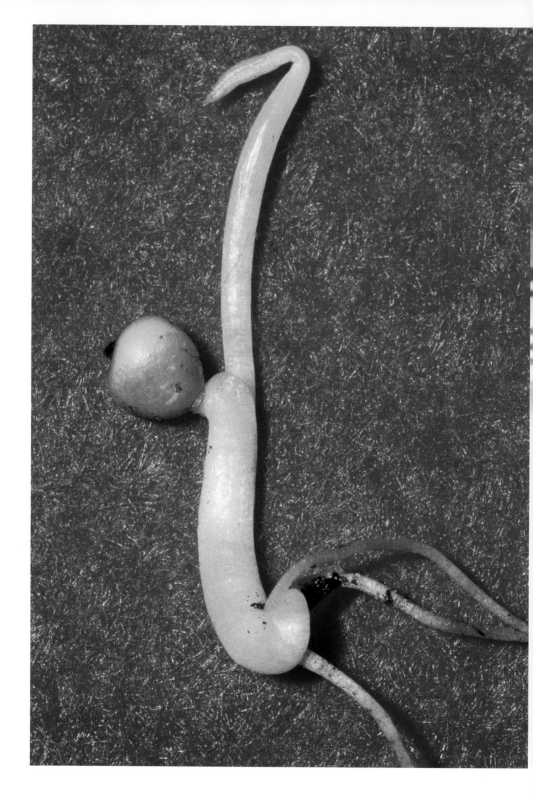

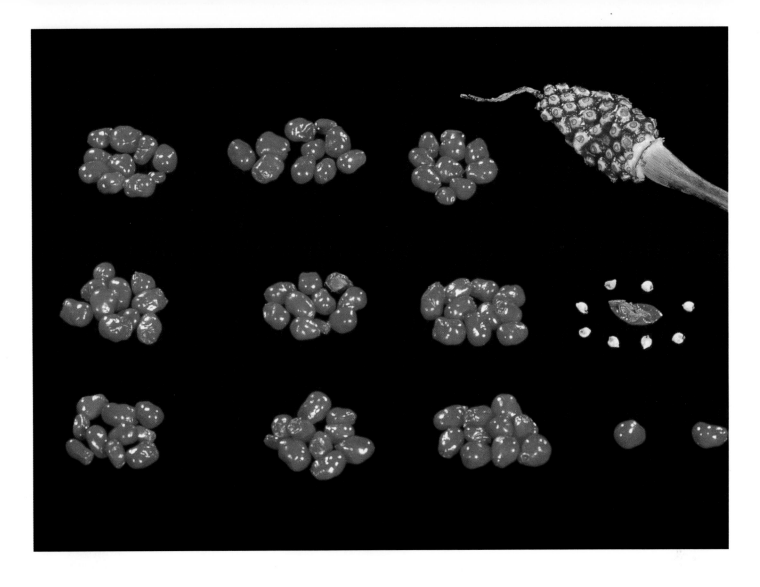

The ninety-three berries shown here all came from one healthy jack-in-the-pulpit plant raised in a pot. Each berry contained about eight seeds. That's approximately 744 seeds from one plant.

In the wild, a jack-in-the-pulpit might not produce as many seeds as this. And of course, not all of them would end up in nourishing locations. But the more seeds a jack-in-the-pulpit produces, the better the chances for new life to grow.

By late fall, most jack-in-the-pulpit berries have been eaten. Soon the part of the plant that grows above ground will wither. But before that happens, let's see what's going on underground.

About three to five inches under the soil is a big potatolike structure that botanists call a corm. The corm is part of the plant's stem system. It has the ability to withstand temperatures much colder than freezing without suffering damage. In wintertime, when the part of the plant above ground dies, the corm survives. Come spring, it sends up a new stem, leaves, and flower structure.

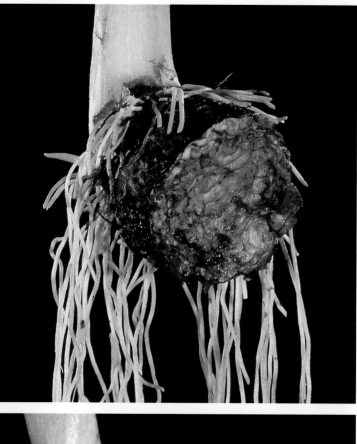

A cross section of a corm looks something like the cross section of a potato. That's because they are both structures for storing food. The corm contains the energy necessary for a jack-in-the-pulpit to grow again in the spring.

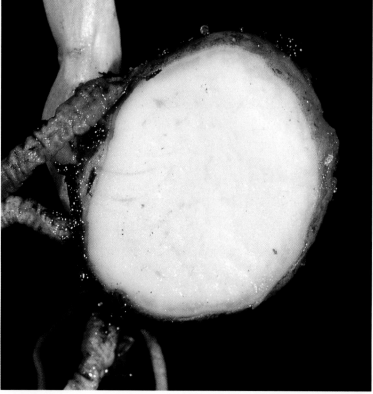

Like all green plants, a jack-in-the-pulpit makes food for itself in its leaves. In the presence of a pigment called chlorophyll, which gives the leaves their green color, sunlight is used to turn carbon dioxide and water into simple sugars. The simple sugars provide the plant with the energy to grow, flower, and (if the flowers are female) to produce seeds.

With plenty of moisture, good soil, and enough sunlight, a jack-in-the-pulpit may make more food than it can use. The extra sugar travels down the stem into the corm, where it is converted to starch—the stored form of sugar.

But don't bite into the corm. It won't be sweet! The merest nibble would burn your mouth. The corm contains calcium oxalate crystals, which protect it against animals that might otherwise try to eat it.

Native Americans apparently knew how to use the corms for food. They boiled them in at least three changes of water, dried them, and then ground them into a kind of flour. That is probably why another name for jack-in-the-pulpit is Indian turnip.

If you wanted to introduce jack-in-the-pulpits into a moist, semi-shaded area where none yet grew, how would you do it? Probably the easiest way would be to scatter a handful of red berries onto the surface of the soil. Or you could remove the seeds and press each one into the earth an inch or two. Or a still better way would be to plant the seeds in flowerpots and then transplant the jack-in-the-pulpits outdoors a few years later. A plant already growing has a better chance of competing for space, water, minerals, and sunlight.

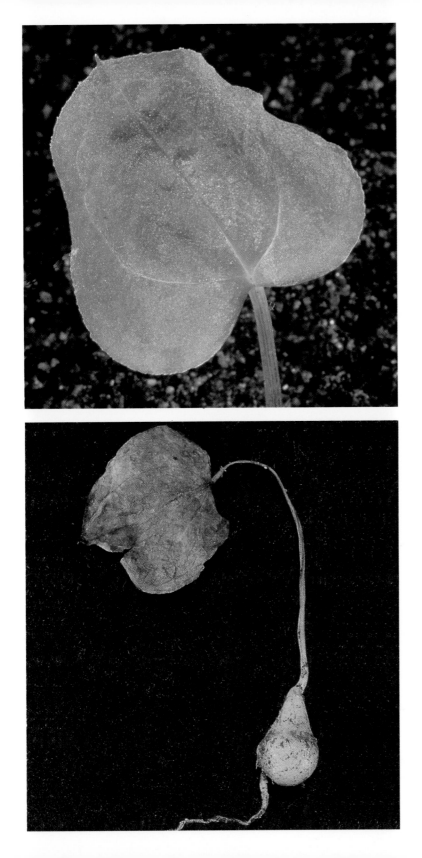

A jack-in-the-pulpit is a slow-growing plant. During its first growing season, from spring to fall, the seed germinates and sends up one small leaf.

Yet in autumn, by the end of the first growing season, even that single small leaf has produced enough extra food to form a fair-sized corm. The corm survives the winter, and in spring it has enough stored energy to send up...

a typical compound leaf for the second growing season. Those three leaflets make even more food for the plant, much of which will be stored in the corm.

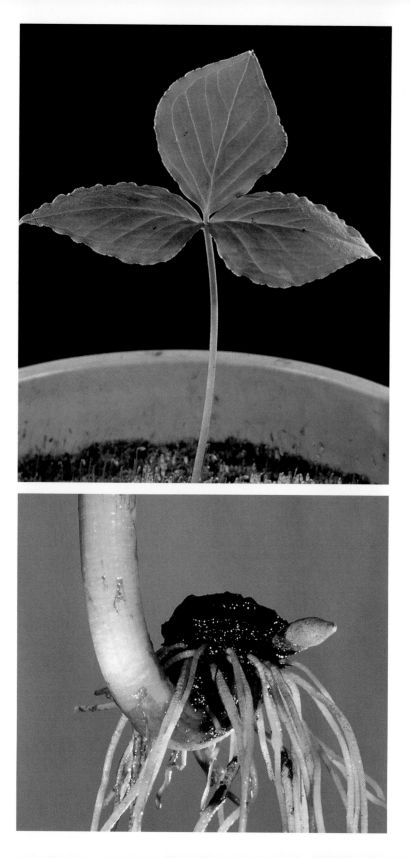

At the end of the second growing season, when the compound leaf has withered, we can carefully remove the plant from the pot to check the corm. Not only is the corm larger, it has produced a bud—a small corm that is still attached to the mother corm.

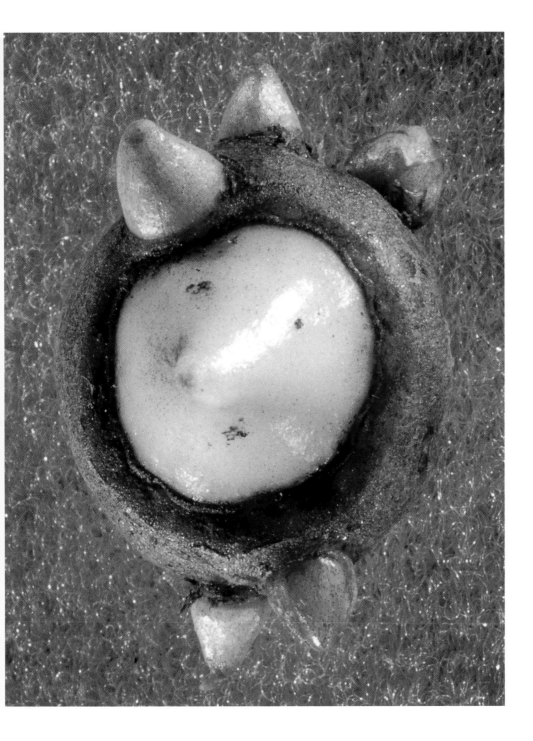

During the third season, growth above ground is much like that of the previous season. Below, the corm has grown and produced several more buds. When a bud on the corm is large enough to support its own plant, it separates from the mother corm.

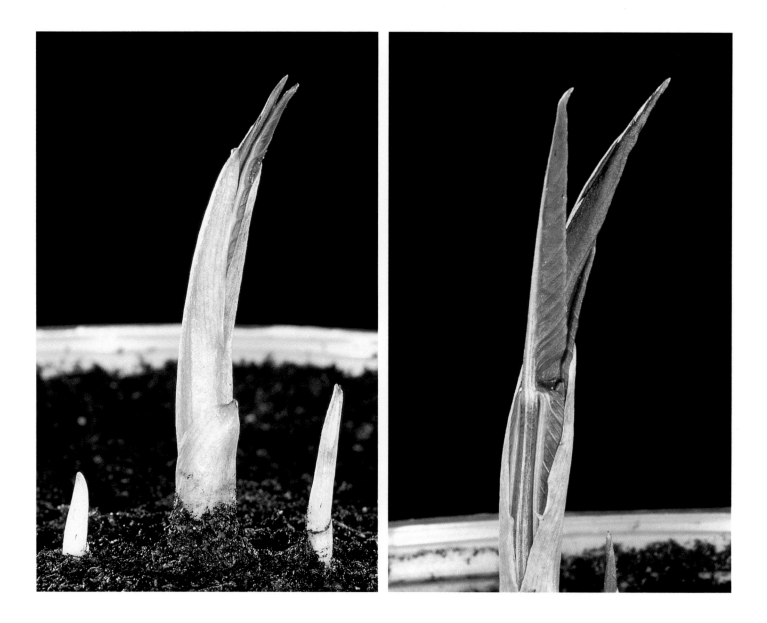

By the fourth season, the corm has stored enough energy to send up leaves *and* a flower structure. Note that two of the bud corms are now large enough to begin growing on their own.

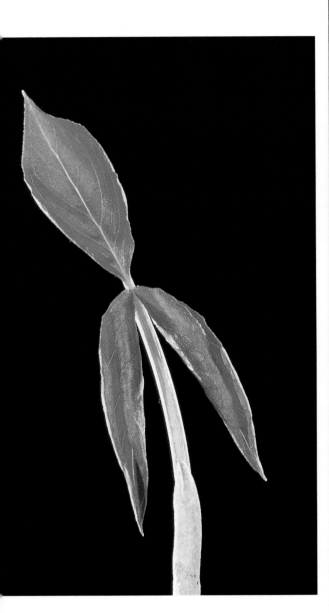

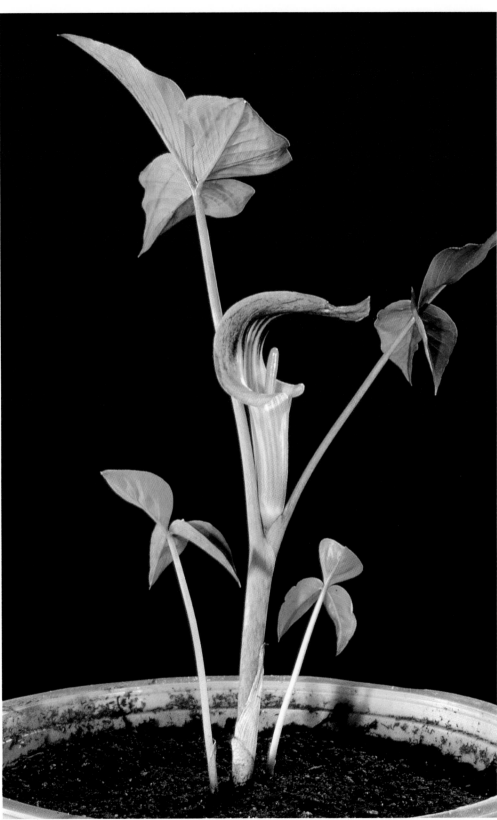

Four years from seed to flower. To grow jack-in-the-pulpits, you need patience!

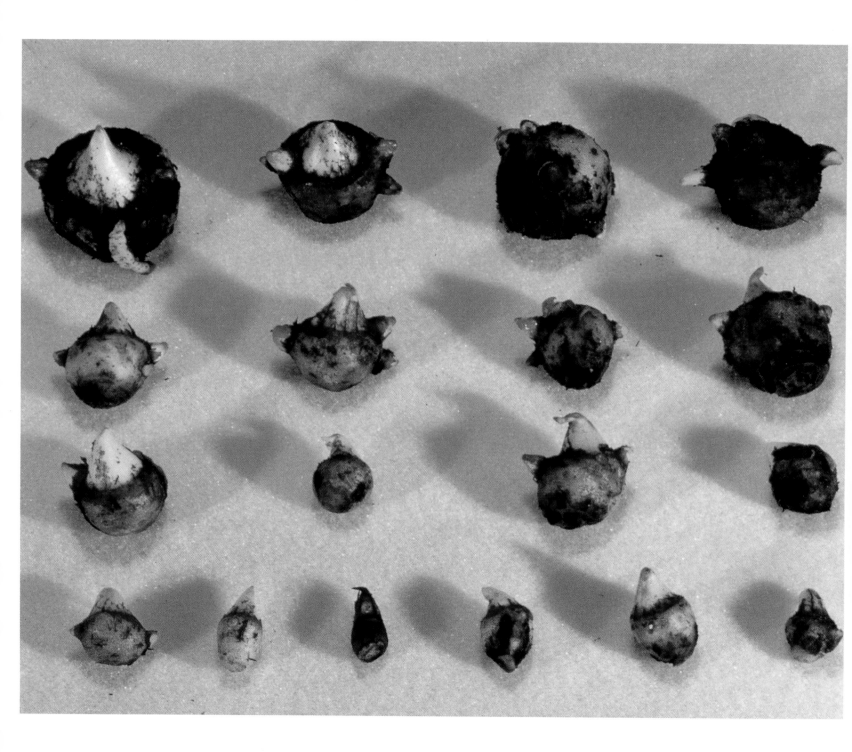

Corms give jack-in-the-pulpits a great advantage in the wild. Seedlings—new plants just sprouted from seeds—must compete with larger plants already established. Generally, the seedlings lose out. But plants that grow from corms are already on their way. And they have their own food supply, too.

The eighteen corms in this picture came from an experiment that started with five jack-in-the-pulpit seeds. The seeds were planted in a large pot, watered and fertilized, but left undisturbed for four growing seasons. At the end of the fourth year, each plant had produced a flower structure; eighteen corms were found in the soil.

From just five seeds came thirteen *new* corms and several thousand more seeds. The seeds and the corms are the jack-in-the-pulpit's way of making future generations, of lasting on earth.

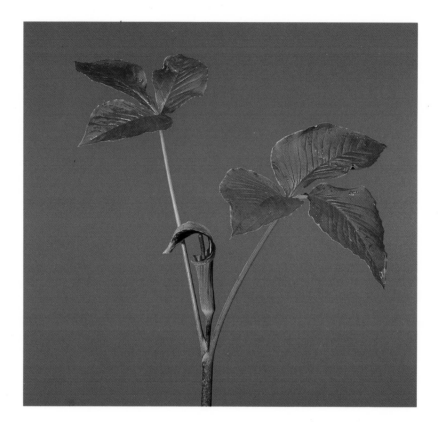

Long may this wildflower live.